WINDS & CURRENTS

Native American Stories

Retold and Illustrated by Joan Henrik

HOLY COW! PRESS :: DULUTH, MINNESOTA :: 2017

Illustrations, Foreword, copyright ©2017 by Joan Henrik.

Book and cover design by Joan Henrik.

Printed and bound in the United States of America.

First printing, Fall, 2017.

ISBN 978-0-9864480-8-9

10 9 8 7 6 5 4 3 2 1

Holy Cow! Press projects are funded in part by grant awards from the Ben and Jeanne Overman Charitable Trust, the Elmer L. and Eleanor J. Andersen Foundation, the Cy and Paula DeCosse Fund of The Minneapolis Foundation, the Lenfestey Family Foundation, and by gifts from generous individual donors.

Holy Cow! Press books are distributed to the trade by Consortium Book Sales & Distribution, c/o Ingram Publisher Services, Inc., 210 American Drive, Jackson, TN 38301.

For inquiries, please write to: Holy Cow! Press, Post Office Box 3170, Mount Royal Station, Duluth, MN 55803.

Visit www.holycowpress.org

CONTENTS

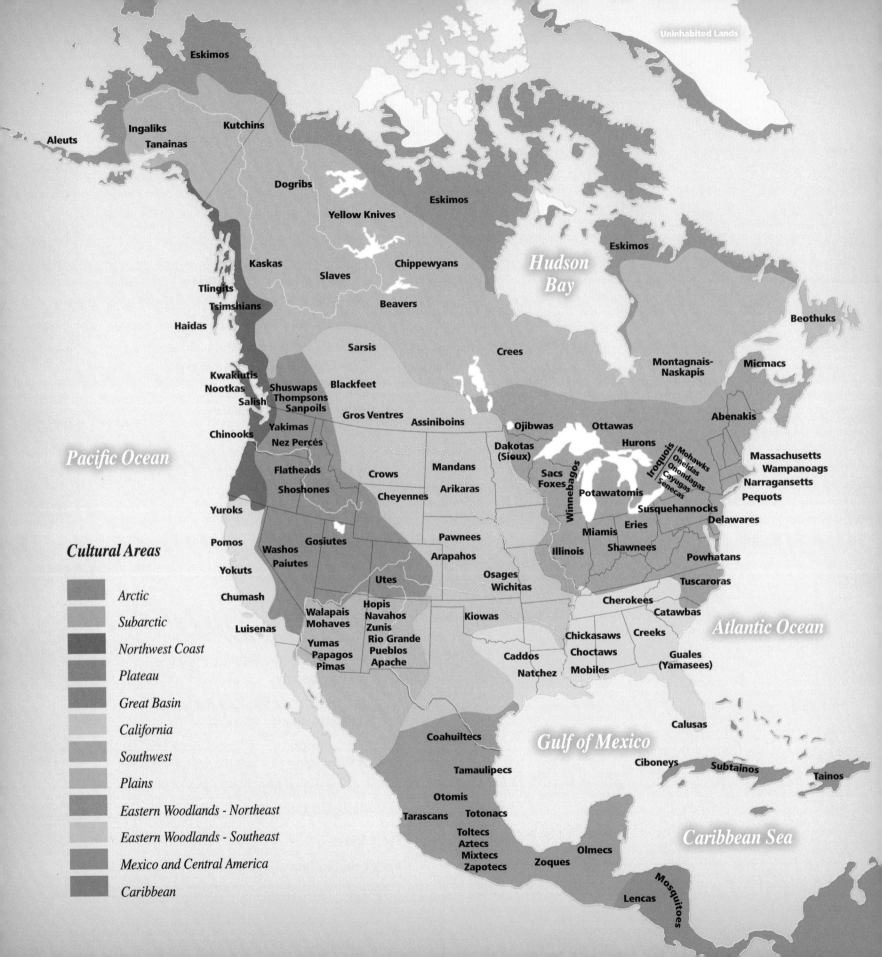

Uninhabited Lands

Eskimos

Aleuts

Ingaliks
Tanainas

Kutchins

Dogribs

Yellow Knives

Eskimos

Hudson
Bay

Eskimos

Kaskas

Slaves

Chippewyans

Beavers

Tlingits

Tsimshians

Haidas

Beothuks

Sarsis

Crees

Montagnais-
Naskapis

Micmacs

Kwakiutis
Nootkas
Salish

Shuswaps
Thompsons
Sanpoils

Blackfeet

Gros Ventres

Assiniboins

Ojibwas

Ottawas

Hurons

Abenakis

Pacific Ocean

Chinooks

Yakimas
Nez Percés

Dakotas
(Sioux)

Massachusetts
Wampanoags

Iroquois

Mohawks
Oneidas
Onondagas
Cayugas
Senecas

Flatheads

Crows

Mandans

Sacs
Foxes

Winnebagos

Narragansetts
Pequots

Shoshones

Cheyennes

Arikaras

Potawatomis

Susquehannocks

Yuroks

Delawares

Miamis

Eries

Pomos

Gosiutes

Pawnees

Illinois

Shawnees

Powhatans

Washos
Paiutes

Arapahos

Yokuts

Utes

Osages
Wichitas

Tuscaroras

Chumash

Hopis
Navahos
Zunis

Cherokees

Catawbas

Atlantic Ocean

Walapais
Mohaves

Luisenas

Kiowas

Chickasaws

Creeks

Yumas
Papagos
Pimas

Rio Grande
Pueblos
Apache

Caddos

Choctaws

Guales
(Yamasees)

Natchez

Mobiles

Calusas

Coahuiltecs

Gulf of Mexico

Ciboneys

Subtainos

Tamaulipecs

Tainos

Otomis

Tarascans

Totonacs

Caribbean Sea

Toltecs
Aztecs
Mixtecs
Zapotecs

Olmecs

Zoques

Mosquitoes

Lencas

Cultural Areas

- *Arctic*
- *Subarctic*
- *Northwest Coast*
- *Plateau*
- *Great Basin*
- *California*
- *Southwest*
- *Plains*
- *Eastern Woodlands - Northeast*
- *Eastern Woodlands - Southeast*
- *Mexico and Central America*
- *Caribbean*

FOREWORD

Native People come from an oral narrative tradition. Storytelling has been for a long time a sacred process because it provided *The People* with social, cultural and historical contexts. In other words, the oral narrative acts as a social cohesive for the entire tribe and constitutes the *cultural grounding* of Indigenous people for thousands of years.

Stories have always been crucial part of ceremonial occasions. Often long and complex, they covered a variety of moods and issues thus constituting one of the most important links in an oral tradition designed to pass on knowledge to succeeding generations. There are a lot of similarities in story content from tribe to tribe. During celebrations, ceremonies and gatherings, stories are shared among tribes; often even given as gifts much like songs are given as gifts. The stories would then be revised according to the region from which the tribe came. If, for example, a gift of a story was given from the plains to a coastal tribe, the creatures would become water creatures as opposed to flat land creatures such as buffalo.

In my Finnish cultural tradition, the heroic tales of mythical figures were sung/shared by the fire, with the story tellers holding each other's hands and rocking to and fro in cadence with the song accompanying the story. Those stories resulted in *The Kalevala* (or *Land of Heroes*). It is a epic poem and book based on folk poetry and collected by Elias Lönnrot. It is considered the national epic of Finland. Undeniably the most influential work of literature there, it's credited with initiating a national awakening that eventually led to Finland's independence and preserving the Finnish language. It inspired J. R. R. Tolkien to write *The Hobbit* and the *Lord of the Rings* trilogy.

When I researched the icons I wanted to imbed in the floor, *(photo of terrazzo floor on front cover)* I discovered stories that had their origins in native folklore. The stories are cautionary tales demonstrating what we can learn from the natural world. The resulting 14 icons were placed on the concrete floor and filled with eleven epoxy terrazzo colors. The aggregate added to the epoxy is mostly domestic marble, Mother of Pearl, and recycled glass.

These exotics were added to highlight special areas like the flowing river descending the stairs. The centerpiece of the floor is a two foot in diameter brass turtle that points to the traditional home of the Anishinabe called Turtle Island (Madeline Island). The island is located on Lake Superior and off the shore of Bayfield, Wisconsin.

The remaining icons are one foot in diameter, laser cut from 3/8" aluminum. The metal divider strips were all hand manipulated to accurately represent nature and its flowing lines. The stairs were cast in place and the installation handwork paid special attention to create the water which cascades down the stairs, maintaining the focus of my design, energy and movement.

From the beginning, the Duluth Entertainment and Convention Center was committed to having terrazzo floors in their new state-of-the-art NHL-sized Ice Arena located on the water's edge of Lake Superior in Duluth, Minnesota. They chose my floor design, *Winds & Currents* to connect the arena to the existing auditorium. A commissioned public 1% for the arts project, this work transformed a simple traffic area, approximately 3,400 square feet, into its own space. The artwork reflects forces that shape our earth and lives. Winds and currents create our rivers and lakes, layer our minerals and soils, and drive the seasons which sustain all life. The terrazzo floor is what's happening in between: the lives of yesterday, today and tomorrow.

The National Terrazzo and Mosaic Association (NTMA) announced the fourteen 2011 Honor Award Recipients. The floor *Winds & Currents* was selected as one of 14 best terrazzo floors in the United States.

This book is dedicated to the story tellers who inspired me to create the icons I chose to be featured in the floor. I included an expanded version of the icon art so that you may add your own color.

I want to thank my daughter Jodie Makovec and her husband Billy for their unwavering help and encouragement. Working with them was truly a labor of love.

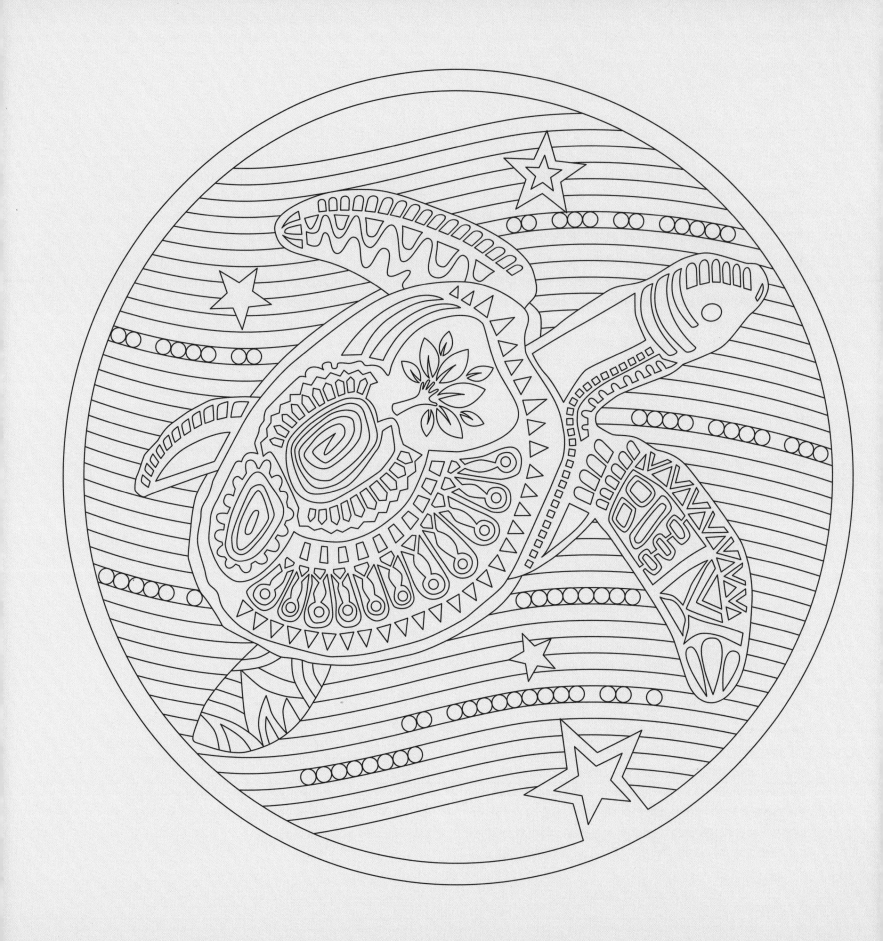

TURTLE GETS A SHELL

An Anishnabe Story

It was one of those days when Nanaboozhoo was in a strange mood. He had just awakened from a deep sleep that was disturbed by the noisy quarreling and scolding of the blue jays. He was a bit cranky; his sleep was disturbed and besides that, he was hungry. His first thought was to go down to the village and find something to eat.

Entering the village, he came across some men cooking fish. They had their camp located close to the water and Nanaboozhoo spied many fish cooking over a fire. Now, being very hungry, he asked for something to eat. The men were happy to give him some, but cautioned him that it was hot. Not heeding their warning, he quickly grabbed the fish and burned his hand. He ran to the lake to cool it off in the water.

Still unsteady from his deep sleep, he tripped on a stone and fell on Mi-she-kae (turtle) who was sunning on the beach. At that time, Mishekae was not as we know her today. She had no shell and her body was comprised of soft skin and bone.

Turtle complained loudly to Nanaboozhoo to watch where he was going. Now, Nanaboozhoo felt ashamed of his clumsiness and apologized to Mishekae. He wondered, "What can I do to make it up to her?" He wanted to do something to help his friend. "I'll have to sit and think it over," he thought, as he followed the path back to his wigwam.

Sometime later, he returned to the beach and called for Mishekae. Turtle poked her head through the soft beach mud. Nanaboozhoo picked up two large shells

from the shore and placed one on top of the other. He scooped up Mishekae and put her right in the middle, between the shells.

Nanaboozhoo took a deep breath and began. "You will never be injured like that again," he said slowly. "Whenever danger threatens," he continued, "you can pull your legs and head into the shell for protection."

Nanaboozhoo sat beside his friend on the beach and told Mishekae his thoughts. "The shell itself is round like Mother Earth. It is a round hump which resembles her hills and mountains. It is divided into segments that are part of her; each different and yet connected by her."

Mishekae seemed very pleased and listened intently. "You have four legs each representing the points of direction North, South, East and West," he said. "When the legs are drawn in, all directions are lost. Your tail will show the many lands where the Anishnabe have been and your head will point in the direction to follow. "You will have advantages over the Anishnabe," he went on. "You will be able to live in the water as well as on land and you will be in your own house at all times."

Mishekae approved of her new self and thanked Nanaboozhoo for his wisdom. Moving now in a thick shell, she pushed herself along the shore and disappeared into the water. So, ever since that accident long ago Turtle has been special to the Anishnabe. To this day, she still honors Mother Earth, still proudly wearing those two shells.

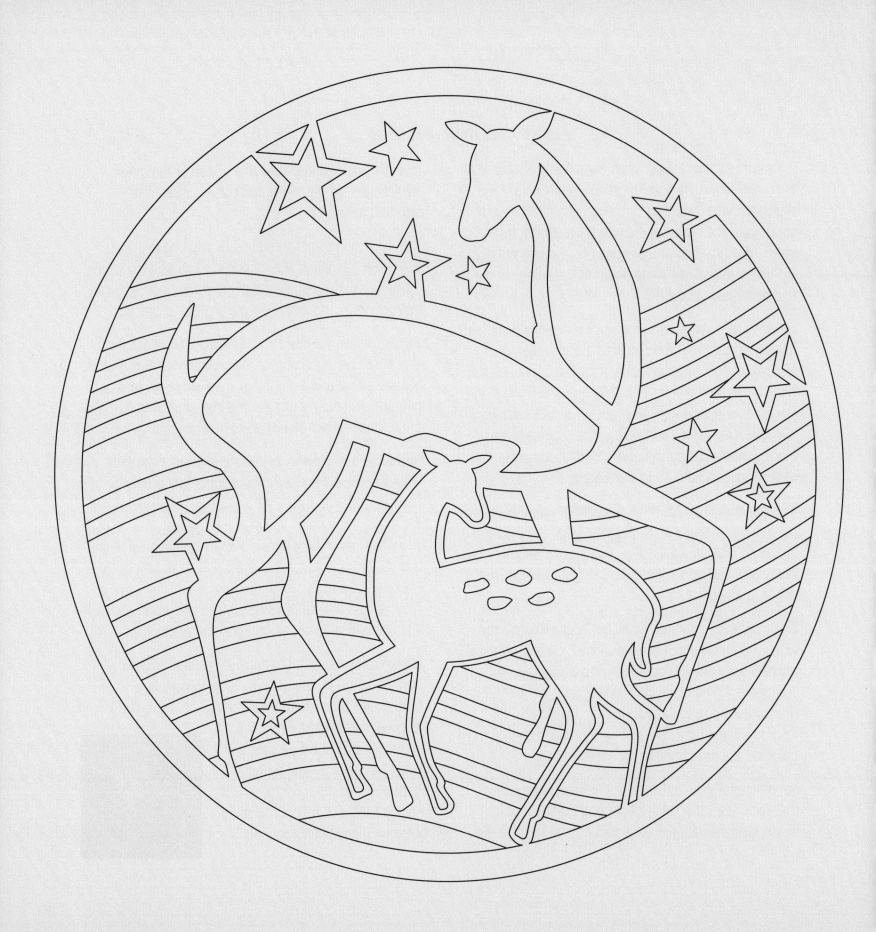

HOW THE FAWN GOT ITS SPOTS

A Dakota Story

Long ago, when the world was new, Wakan Tanka, The Great Mystery, was walking around. As he walked he spoke to himself of the may things he had done to help the four-legged ones and the birds survive.

"It is good," Wakan Tanka said. "I have given Mountain Lion sharp claws and Grizzly Bear great strength; it is much easier now for them to survive.

"I have given Wolf sharp teeth and I have given his brother, Coyote, quick wits: it is much easier now for them to survive.

"I have given Beaver a flat tail and webbed feet to swim beneath the water and teeth which can cut down the trees and I have given slow-moving Porcupine, quills to protect itself. Now it is easier for them to survive.

"I have given the Birds their feathers and the ability to fly so that they may escape their enemies. I have given speed to Deer and the Rabbit so that it will be hard for their enemies to catch them. Truly it is now much easier for them to survive."

However, as Wakan Tanka spoke, a mother Deer came up to him. Behind her was her small Fawn, wobbling on weak new legs.

"Great One," she said, "It is true that you have given many gifts to the four-leggeds and winged ones to help them survive. It is true that you gave me great speed and now my enemies find it hard to catch me. My speed is a great protection, indeed.

But what of my little one here? She does not yet have speed. It is easy for our enemies, with their sharp teeth and their claws to catch her. If my children do not survive, how can my people live?"

"Wica yaka pelo!" said Wakan Tanka. "You have spoken truly; you are right. Have your little one come here and I will help her."

Then Wakan Tanka made paint from the earth and the plants. He painted spots upon the fawn's body so that when she lay still her color blended in with the earth and she could not be seen. Then Waka Tanka breathed upon her, taking away her scent.

"Now," Wakan Tanka said, "your little ones will always be safe if they only remain still when they are away from your side. None of your enemies will see your little ones or be able to catch their scent."

So it has been from that day on. When a young deer is too small and weak to run swiftly, it is covered with spots that blend in with the earth. It has no scent and it remains very still and close to the earth when its mothers is not by its side. And when it has grown enough to have the speed Wakan Tanka gave its people, then it loses those spots it once needed to survive.

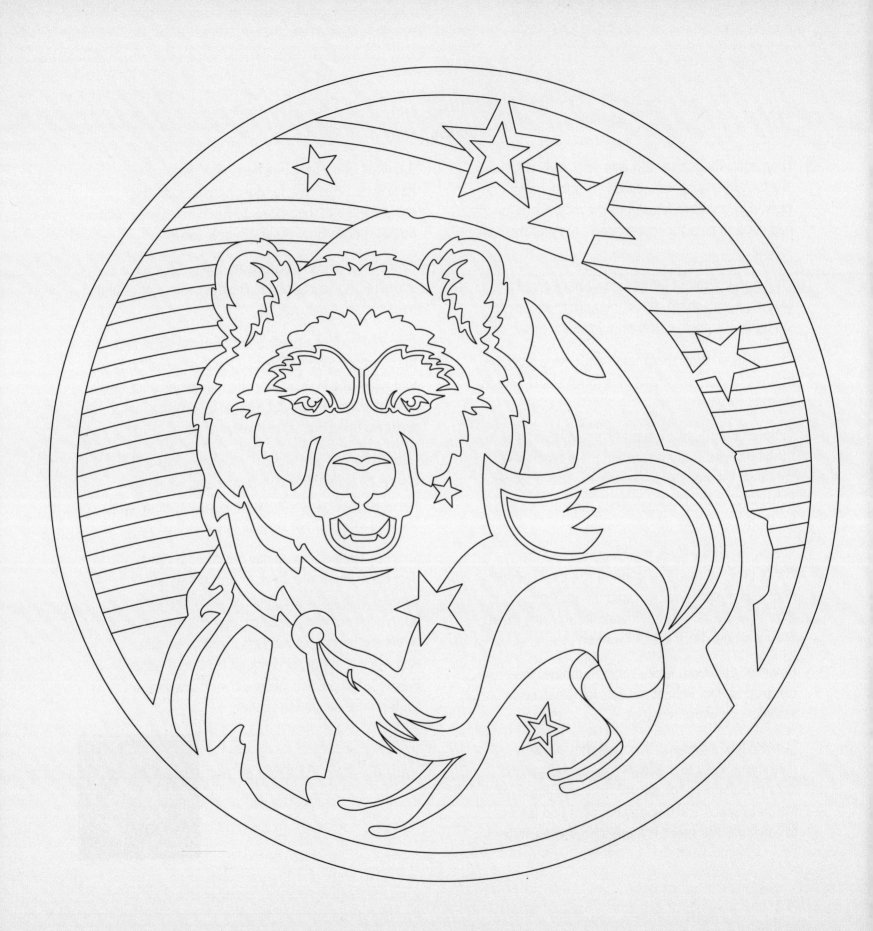

HOW THE BEAR LOST HIS TAIL

An Anishinabe Story

In the beginning, bear had a long, bushy tail of which he was quite proud. Bear loved to show off his tail to all the other animals, including fox. Now fox loved to play tricks, and one day decided to have some fun at bear's expense.

It was winter, and the lake had frozen. Fox knew the path bear took by the lake and decided to lure bear with some fish. Fox cut a hole in the ice and stacked many fish next to it. Fox knew bear loved to eat fish, but so did fox. Fox didn't want bear to fish in this spot, fearing bear would eat up all the fish.

When bear saw all the fish he was excited. He asked fox to teach him how to catch so many fish. Bear swore he would do everything fox told him, so fox agreed. Fox took bear to another spot in the lake and cut a hole in the ice.

Fox turned to bear and told him he must put his bushy tail into the water to catch the fish. Fox told bear he must sit very still. Fox warned bear that bear should not think of anything because fish can read thoughts. Fox went off into the bushes, and said he would tell bear when to pull his tail out of the water.

Bear did as he was told. He did not move, and he did not think. Fox watched bear sitting so still and laughed and laughed, rolling upon the ground. But, soon fox grew tired and went home.

The next morning, fox went back to the lake, wondering if bear had gone home. It had snowed during the night. When fox approached the lake he saw a mound on the ice covered with snow. The mound was bear, who had fallen asleep. Fox burst out laughing. Quietly, fox crept up to bear, and began to shout, "Now bear! Now! Pull your tail up now!"

Hearing the commands, bear woke up and immediately tried to pull his tail out of the water. As he pulled, a loud snap was heard. Bear turned to look, thinking he had caught a lot of fish. But there were no fish. Bear's beautiful tail had frozen in the water and broken off when he tried to pull it out.

Groaning, bear yelled at fox. Bear was angry because he lost his tail through fox's trick. Bear swore he would get even with fox. Fox just laughed and laughed at bear and his missing tail. Bear became more angry and leapt at fox. But, fox was too fast and ran away laughing.

To this day, bear continues to have a short tail, and still does not like fox. Sometimes in the woods a bear's groaning can be heard. Bear groans because he is remembering the trick fox played long ago and continues to mourn the loss of his beautiful tail.

HOW RABBIT BROUGHT FIRE TO THE PEOPLE

A Native American Story

In the beginning there was no fire and the earth was cold. Then the Thunderbirds sent their lightning to a sycamore tree on an island where the Weasels lived. The Weasels were the only ones who had fire and they would not give any of it away.

The people knew that there was fire on the island because they could see smoke coming from the sycamore, but the water was too deep for anyone to cross. When winter came the people suffered so much from the cold that they called a council to find some way of obtaining fire from the Weasels. They invited all the animals who could swim.

"How shall we obtain fire?" the people asked.

Most of the animals were afraid of the Weasels because they were bloodthirsty and ate mice and moles and fish and birds. Rabbit was the only one who was brave enough to try to steal fire from them. "I can run and swim faster than the Weasels," he said. "I am also a good dancer. Every night the Weasels build a big fire and dance around it. Tonight I will swim across and join in the dancing. I will run away with some fire."

He considered the matter for a while and then decided how he would do it. Before the sun set he rubbed his head with pine tar so as to make his hair stand up. Then, as darkness was falling, he swam across to the island.

The Weasels received Rabbit gladly because they had heard of his fame as a dancer. Soon they had a big fire blazing and all began dancing around it. As the Weasels danced, they approached nearer and nearer the fire in the centre of the circle. They would bow to the fire and then dance backwards away from it.

When Rabbit entered the dancing circle, the Weasels shouted to him, "Lead us, Rabbit!" He danced ahead of them, coming closer and closer to the fire. He bowed to the fire, bringing his head lower and lower as if he were going to take hold of it. While the Weasels were dancing faster and faster, trying to keep up with him, Rabbit suddenly bowed very low so that the pine tar in his hair caught fire in a flash of flame.

He ran off with his head ablaze, and the angry Weasels pursued him, crying, "Catch him! Catch him! He has stolen our sacred fire! Catch him, and throw him down!"

But Rabbit outran them and plunged into the water, leaving the Weasels on the shore. He swam across the water with the flames still blazing from his hair.

The Weasels now called on the Thunderbirds to make it rain so as to extinguish the fire stolen by Rabbit. For three days rain poured down upon the earth, and the Weasels were sure that no fire was left burning except in their sycamore tree.

Rabbit, however, had built a fire in a hollow tree, and when the rain stopped and the sun shone, he came out and gave fire to all the people. After that whenever it rained, they kept fires in their shelters, and that is how Rabbit brought fire to the people.

THE LEGEND OF THE CEDAR TREE

A Cherokee Story

A long time ago when the Cherokee people were new upon the earth, they thought that life would be much better if there was never any night. They beseeched the Ouga (Creator) that it might be day all the time and that there would be no darkness.

The Creator heard their voices and made the night cease and it was day all the time. Soon, the forest was thick with heavy growth. It became difficult to walk and to find the path. The people worked in the gardens many long hours trying to keep the weeds pulled from among the corn and other food plants. It got hot, very hot, and continued that way day after long day. The people began to find it difficult to sleep and became short tempered and argued among themselves.

Not many days had passed before the people realized they had made a mistake and, once again, they beseeched the Creator. "Please," they said, "we have made a mistake in asking that it be day all the time. Now we think that it should be night all the time." The Creator paused at this new request and thought that perhaps the people may be right even though all things were created in twos... representing to us day and night, life and death, good and evil, times of plenty and those times of famine. The Creator loved the people and decided to make it night all the time as they had asked.

The day ceased and night fell upon the earth. Soon, the crops stopped growing and it became very cold. The people spent much of their time gathering wood for the fires. They could not see to hunt meat and with no crops growing it was not long before the people were cold, weak, and very hungry. Many of the people died.

Those that remained still living gathered once again to beseech the Creator. "Help us Creator," they cried! "We have made a terrible mistake. You had made the day and the night perfect, and as it should be, from the beginning. We ask that you forgive us and make the day and night as it was before."

Once again the Creator listened to the request of the people. The day and the night became, as the people had asked, as it had been in the beginning. Each day was divided between light and darkness. The weather became more pleasant, and the crops began to grow again. Game was plentiful and the hunting was good. The people had plenty to eat and there was not much sickness. The people treated each other with compassion and respect. It was good to be alive. The people thanked the Creator for their life and for the food they had to eat. The Creator accepted the gratitude of the people and was glad to see them smiling again. However, during the time of the long days of night, many of the people had died, and the Creator was sorry that they had perished because of the night. The Creator placed their spirits in a newly created tree. This tree was named a-tsi-na tlu-gv [ah-see-na loo-guh] cedar tree.

When you smell the aroma of the cedar tree or gaze upon it standing in the forest, remember that if you are Tsalagi (Cherokee), you are looking upon your ancestor.

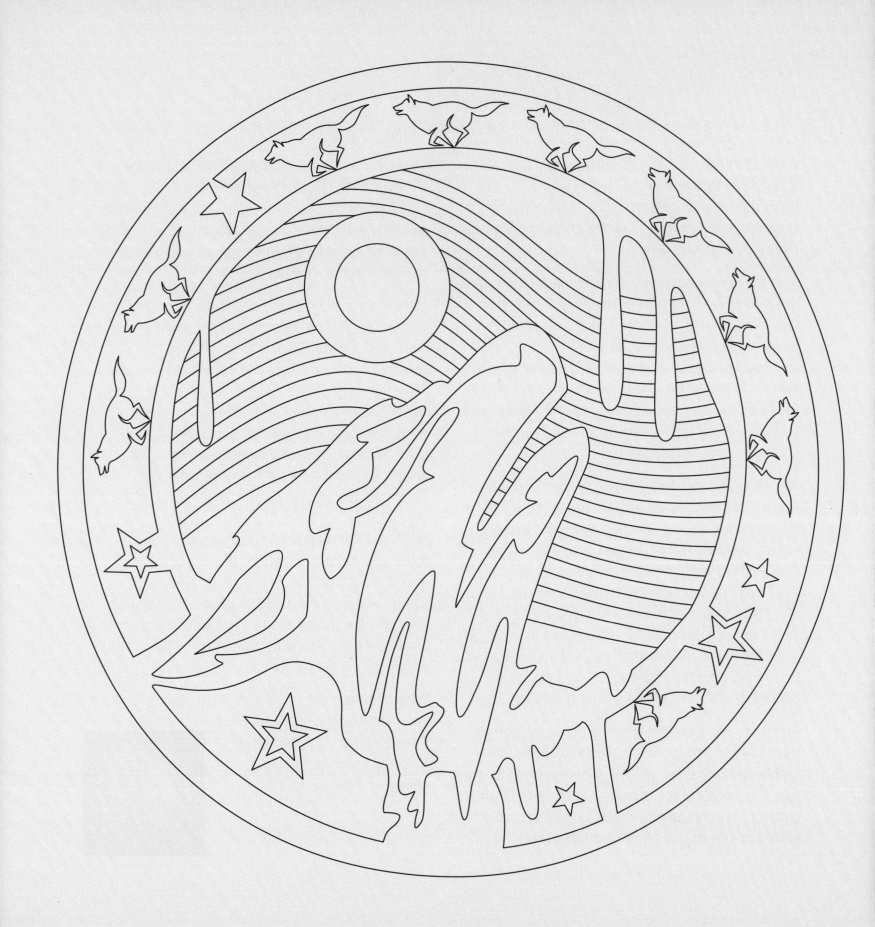

WOLF TRICKS THE TRICKSTER
A Shoshone Story

The Shoshone people saw the Wolf as a creator God and they respected him greatly. Long ago, Wolf, and many other animals, walked and talked like man.

Coyote could talk, too, but the Shoshone people kept far away from him because he was a Trickster, somebody who is always up to no good and out to double-cross you. Coyote resented Wolf because he was respected by the Shoshoni. Being a devious Trickster, Coyote decided it was time to teach Wolf a lesson. He would make the Shoshone people dislike Wolf, and he had the perfect plan. Or so he thought.

One day, Wolf and Coyote were discussing the people of the land. Wolf claimed that if somebody were to die, he could bring them back to life by shooting an arrow under them. Coyote had heard this boast before and decided to put his plan into action.

Wearing his most innocent smile he told Wolf that if he brought everyone back to life, there would soon be no room left on Earth. Once people die, said Coyote, they should remain dead. If Wolf takes my advice, thought Coyote, then the Shoshoni people would hate Wolf, once and for all.

Wolf was getting tired of Coyote constantly questioning his wisdom and knew he was up to no good, but he didn't say anything. He just nodded wisely and decided it was time to teach Coyote a lesson. A few days after their conversation, Coyote came running to Wolf. Coyote's fur was ruffled and his eyes were wide with panic.

Wolf already knew what was wrong: Coyote's son had been bitten by Rattlesnake and no animal can survive the snake's powerful venom. Coyote pleaded with Wolf to bring his son back to life by shooting an arrow under him, as he claimed he could do. Wolf reminded Coyote of his own remark that people should remain dead. He was no longer going to bring people back to life.

The Shoshone people say that was the day Death came to the land and that, as a punishment for his mischievous ways, Coyote's son was the first to die.

No one else was ever raised from the dead by Wolf again, and the people came to know sadness when someone dies. Despite Coyote's efforts, however, the Shoshone didn't hate Wolf. Instead, they admired his strength, wisdom and power, and they still do today.

THE TWO WOLVES
A Cherokee Story

One evening an old Cherokee told his grandson about a battle that goes on inside people. He said, "My son, the battle is between two wolves inside us all. One is Evil. It is anger, envy, jealousy, sorrow, regret, greed, arrogance, self-pity, guilt, resentment, inferiority, lies, false pride, superiority, and ego.

The other is Good. It is joy, peace, love, hope, serenity, humility, kindness, benevolence, generosity, empathy, truth, compassion and faith."

The grandson thought about this for a minute and then asked the grandfather, "Which wolf wins?" The old Cherokee simply replied, "The one you feed."

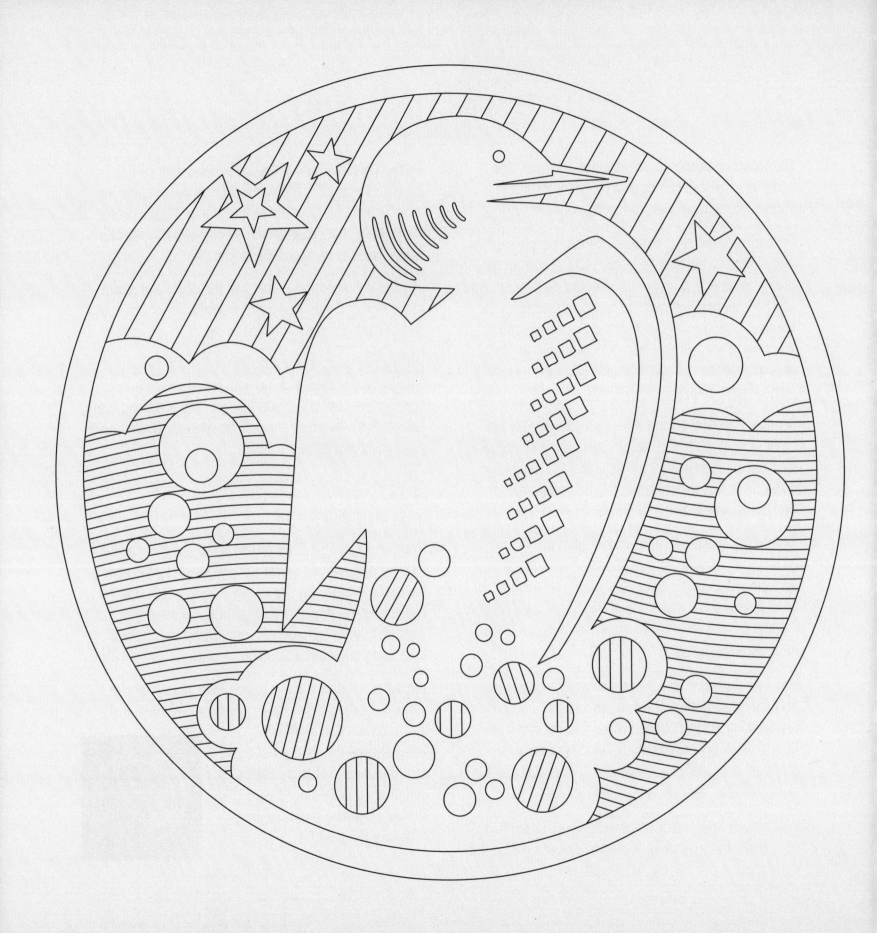

THE LOON'S NECKLACE

A Tsimshian Story

On the bank of the Nicola river, in the Native village of Shalus, there lived an old blind man named Kilora. Though he called himself a medicine man, he did little but dream, day in and day out all the while sitting in front of his house. His wife was impatient with him, snapping at him for his laziness and refusal to help with finding food and other supplies. "There are other blind men in the world and they have baskets to make and beads to polish, yet you sit there grinning at the sun."

The Old Man didn't take any offense at his wife's nagging, and continued to dream. Only one sound was certain to rouse him, the cry of the Loon. When he heard it, a strange restlessness overcame him. He would fumble for his walking stick, and grope his way up the trail toward the sound and Mammoth Lake.

Sometimes he would be gone for days. One year, snow and bitter winds ushered in the coldest winter the village had ever known. The hunters returned with empty hands. And so it was day after day, they were unable to find food. The people were starving. Famine threatened the village.

The chief and medicine men debated whether they should send their young men to nearby Kamloops and Lillooet with articles to trade for food. The next day Kilora warned that the wolves were hungry and they would venture into the village and attack the children. Everyone thought he was a crazy old man and they all laughed at him, until at dusk they heard the howl of the wolves and the cries of the children as they were attacked. Kilora decided he had to use his magical powers to save the village. He'd spent many days alone in his youth communing with the spirits of nature. He put on his dentalion white shell necklace, along with his magical bow and his sacred songs. He shot an arrow from the magical bow at the wolves and it found its mark. The wolves did not come again and there was peace in the village.

When spring finally came, Kilora was determined to go once more to the hilltop to seek his father, the loon. All day he wandered listening for that stirring cry but did not hear it. As he felt the glow of the setting sun on his left cheek, he knew the little lake was ahead of him. He was bitten by mosquitoes and startled by the harsh cry of the night bird. The night winds swept the forest bringing a thunderstorm. Quickly the storm was over and the pale moon sailed across the sky.

"Oh my father, the loon help me yet once again." Father Loon floated over. "What is it that my son desires?" "I am blind my father, would that I could see." "Climb upon my back." Kilora did as requested and loon dived below the waters and swam swiftly and strong toward the far shore. "Can you now see, my son?"

"Now I see, I can see!" Kilora gave thanks to his Father the Loon. Nothing but the dearest of his treasures would suffice as a gift. He drew of his collar of dentalion shells. He tossed it gently to the Loon and it settled around his neck; a few of the shells broke free and scattered across his back. As sure as it is to this day, the Loon received his necklace.

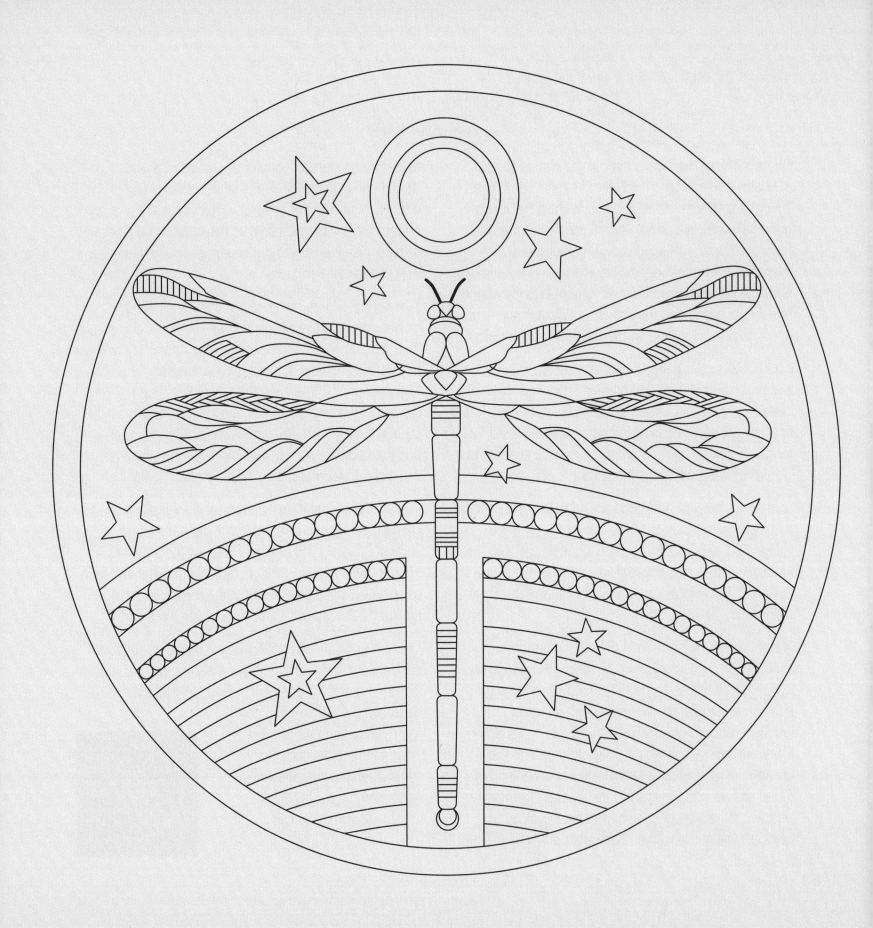

THE BOY WHO MADE A DRAGONFLY

A Zuni Story

A village came on hard times and its people were hungry, so they left their homes in search of a more prosperous land. They didn't know that they had left behind a young boy and a young girl. The girl was very upset at having been left behind. To please her, her brother made her a insect doll from corn and other grasses and gave it to his sister. This corn doll being soon came to life, a messenger from the Great Spirit sent to teach the children how to live their lives.

But the girl became very sick. The corn doll flew away to the south, seeking the corn maidens to help the girl recover and to comfort the children. When the corn maidens arrived, they gave the children food and told them that they were beloved by the Great Spirit. They were destined to become great leaders, the mother and father of their people.

The land grew fertile again and the people returned to their village, finding the boy and girl they had left behind. Because the Great Spirit had visited the children and blessed them, they became great leaders of their people, just as the corn maidens had foretold.

But the corn being was lonely and wished for a companion. He went to the boy and asked him to make another corn being so that he would not be alone. He asked that the boy and his people to call him, his companion, and all of their offspring, dragonflies. Because the corn being had helped him in his time of need, the boy agreed. He made a new corn being like the old

and it too came to life. The boy told the dragonfly, "I will paint your image on sacred things to symbolize spring and the spring rains that bring health to my people. I will paint your companion's image as a symbol of summer and the summer rains."

Even today, the black, white, and red dragonfly arrives in the summer with the blooming of the corn. He is followed by his companion, the green dragonfly. Together they arrive with the rains, bringers of life and good health for the spring and summer.

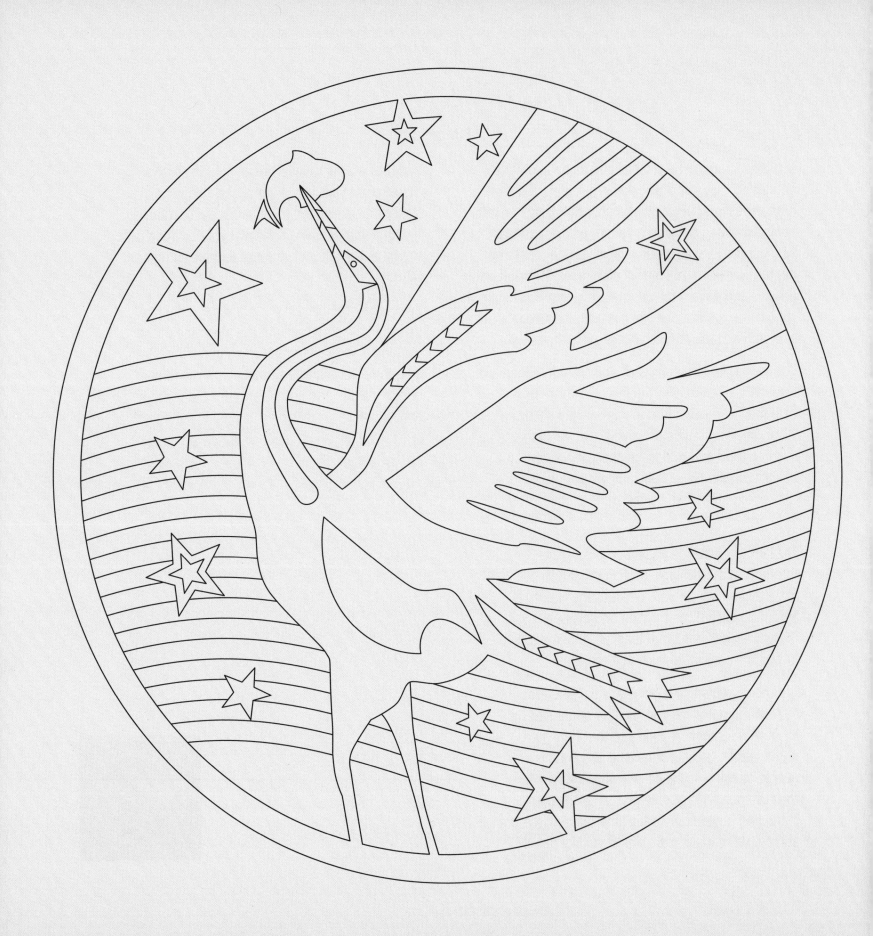

CRANE THE FISHER

A Puyallup Story

A long time ago, Crane was known by all the animals as a great fisherman, although he was only able to catch fish in shallow water. Little Diver was also skilled at catching fish, but did all her fishing in deep water. Crane admired Little Diver, both for her fishing ability and for her slim, glossy, and graceful neck. Crane fell in love with little Diver and asked her to be his wife. Since Little Diver thought it would be great fun to be Crane's wife and have him fish for her while she kept house and enjoyed herself in the company of other birds, she consented to marry him. Crane thought he and Little Diver would live happily together. He believed that she would continue to dive after fish in deep water, and he would continue to wade for fish in shallow water. This would allow them to always have a good supply of food.

Arrangements were quickly made for the wedding. Birds from far and wide were invited. After the marriage ceremony was over, a big dinner of many varieties of fish was served. On the morning following the wedding, Crane, as usual went fishing. He only caught enough fish for himself, expecting his wife to catch her usual supply. Much to his surprise, his wife went swimming instead of fishing. Before Crane left home the next morning, she told him very plainly that it was the duty of a good husband to provide food for his family and that she did not feel that it would be necessary for her to help him. Poor Crane had to fish twice as hard to catch enough for the two of them.

The following morning, Crane's wife told him that one of her relatives would be having dinner with them that evening. This meant that poor Crane had to wade in deeper water and work three times as hard as he had ever done before he was married. Worse still, his wife's relative did not leave after dinner. A few days later, another relative of his wife came to live with them. Crane said nothing about his increased responsibilities and instead worked harder and harder. In order to catch more fish, Crane had to fish in water so deep that he had to stand on his tiptoes while he was fishing. To make matters worse, his wife's relatives continued to arrive. They never helped him fish and greedily ate every morsel he caught.

To catch enough fish to feed such a big family, Crane needed to have longer legs so he could wade into deeper water. He began to lengthen his legs by pulling and stretching them as far as he could. As days passed, Crane kept stretching his legs. They gradually became longer as well as bluer from wading in such cold water. Finally, there was no flesh left on his legs at all; they were nothing but long bones covered with scaly skin. Crane has never been able to wade out far enough to catch enough fish for is wife and her relatives. That is why, even today, Crane always has such a forlorn and worried look.

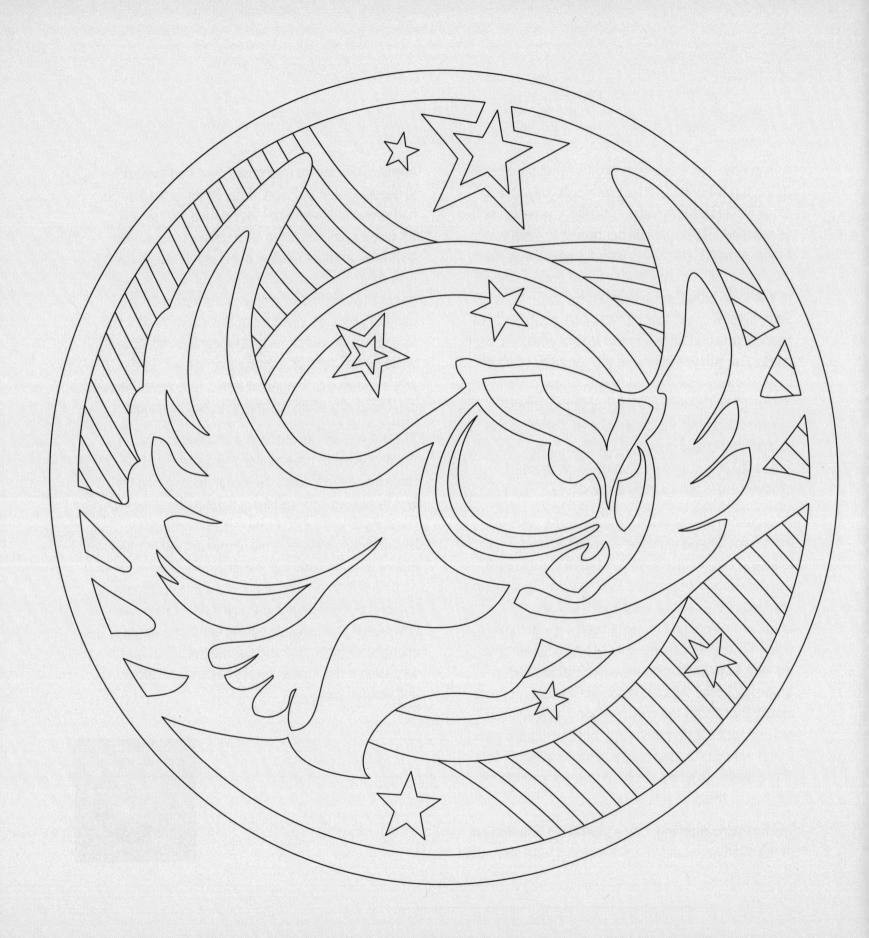

WISE OWL
A Woodland Indian Story

Once upon a time, a long time ago, the Everything-Maker was very busy, making all the animals and all the plants and all the rocks and caves and everything else that covered the earth. Owl had not yet been made. He had been given a voice. And two eyes. And a head and a body and strong wings. Owl was waiting his turn to be formed.

"I want a long neck like Swan," Owl told the Everything-Maker. "I want red feathers like Cardinal and a beak like Hawk."

"Yes, yes," mumbled the Everything-Maker. "Whatever you want. But you must wait your turn." The Everything-Maker looked sharply at Owl. "Your eyes are open again. You know that no one is allowed to watch me work. Turn around and close your eyes. I have no time for you now. I am busy creating Rabbit."

The Everything-Maker turned his attention back to Rabbit who was shaking with nervousness. "And what do you want, little rabbit?" the Everything-Maker asked encouragingly.

"Long legs and ears," Rabbit spoke softly. "And fangs. Could I possibly have a fang or two? And claws. I would dearly love to have claws!"

The Everything-Maker smiled. "I think we could manage some claws and fangs." He smoothed Rabbit's long legs and ears.

"Silly Rabbit!" Owl hooted loudly. "Why don't you ask for something useful, like wisdom? This is your last warning, Owl. Be quiet and wait your turn."

Owl twisted around and glared at the Everything-Maker. "You have to do it," he hooted. "You have to give us what we ask. I demand wisdom!"

"I warned you, Owl!" shouted the Everything-Maker. He shoved Owl's head down into his body, which made Owl's neck disappear. He gave Owl a shake, which made Owl's eyes widen in fright. He pulled Owl's ears until they stuck out from his head.

The Everything-Maker snapped his fingers. "I have made your ears big, the better to listen. I have made your eyes big, the better to see. I have made your neck short, the better to hold up your head. I have packed your head with wisdom, as you have asked. Now, use your wisdom and fly away before you lose what I have given."

Owl was no longer a fool. He flew quickly away, pouting and hooting.

The Everything-Maker turned back to Rabbit, smiling gently. "Claws," he reminded himself. But Rabbit was gone. Rabbit had hopped hurriedly away, too afraid of the Everything-Maker to stay for his fangs and claws.

As for Owl, he knew if he angered the Everything-Maker again, he would lose all that he had gained. Even today, Owl only comes out at night, when the Everything-Maker is fast asleep. As for Rabbit, his claws and fangs are waiting. Perhaps someday.

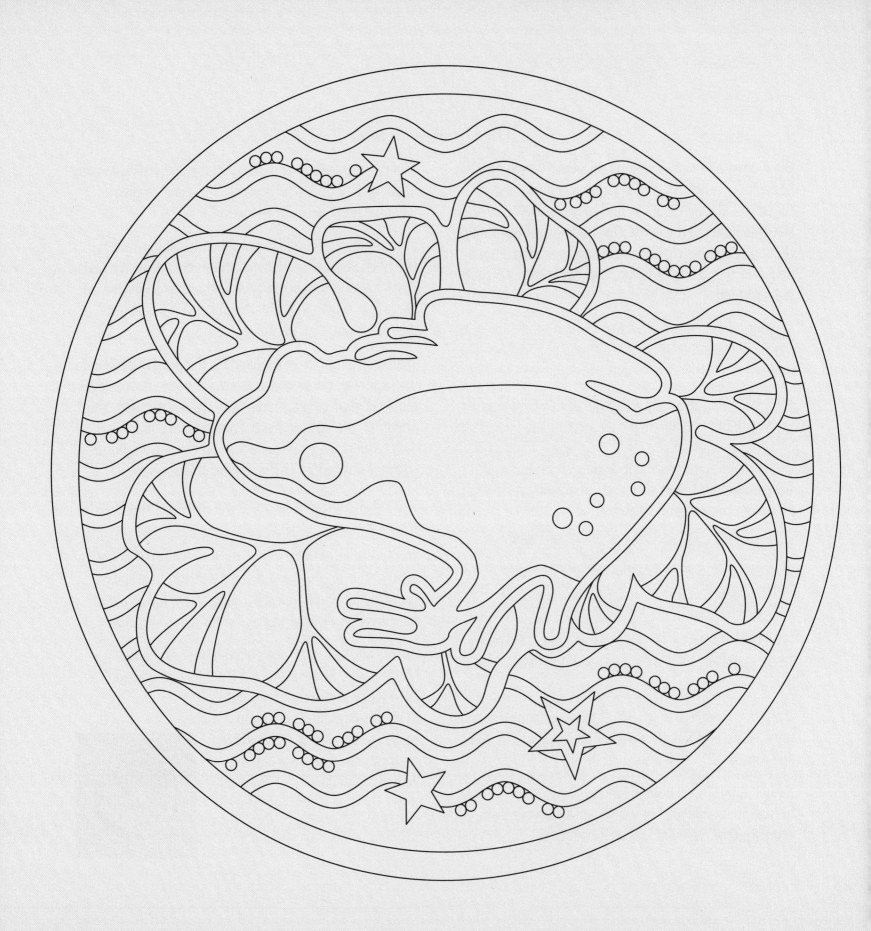

HOW FROG HELPED CREATE THE WORLD

An Iroquois Story

Long before the world was created there was an island, floating in the sky, upon which the Sky People lived. They lived quietly and happily. No one ever died or was born or experienced sadness. However one day one of the Sky Women realized she was going to give birth to twins. She told her husband, who flew into a rage. In the center of the island there was a tree which gave light to the entire island since the sun hadn't been created yet.

He tore up this tree, creating a huge hole in the middle of the island. Curiously, the woman peered into the hole. Far below she could see the waters that covered the earth. At that moment her husband pushed her. She fell through the hole, tumbling towards the waters below.

Water animals already existed on the earth, so far below the floating island two birds saw the Sky Woman fall. Just before she reached the waters they caught her on their backs and brought her to the other animals. Determined to help the woman they dove into the water to get mud from the bottom of the seas. One after another the animals tried and failed. Finally, Little Toad tried and when he reappeared his mouth was full of mud. The animals took it and spread it on the back of Big Turtle. The mud began to grow and grow and grow until it became the size of North America.

Then the woman stepped onto the land. She sprinkled dust into the air and created stars. Then she created the moon and sun.

The Sky Woman gave birth to twin sons. She named one Sapling. He grew to be kind and gentle. She named the other Flint and his heart was as cold as his name. They grew quickly and began filling the earth with their creations.

Sapling created what is good. He made animals that are useful to humans. He made rivers that went two ways and into these he put fish without bones. He made plants that people could eat easily. If he was able to do all the work himself there would be no suffering.

Flint destroyed much of Sapling's work and created all that is bad. He made the rivers flow only in one direction. He put bones in fish and thorns on berry bushes. He created winter, but Sapling gave it life so that it could move to give way to Spring. He created monsters which his brother drove beneath the Earth.

Eventually Sapling and Flint decided to fight till one conquered the other. Neither was able to win at first, but finally Flint was beaten. Because he was a Spirit, Flint could not die, so he was forced to live on Big Turtle's back. Occasionally his anger is felt in the form of a volcano.

The Iroquois people hold a great respect for all animals. This is mirrored in their creation myth by the role the animals play. Without the animals' help the Sky Woman may have sunk to the bottom of the sea and earth may not have been created.

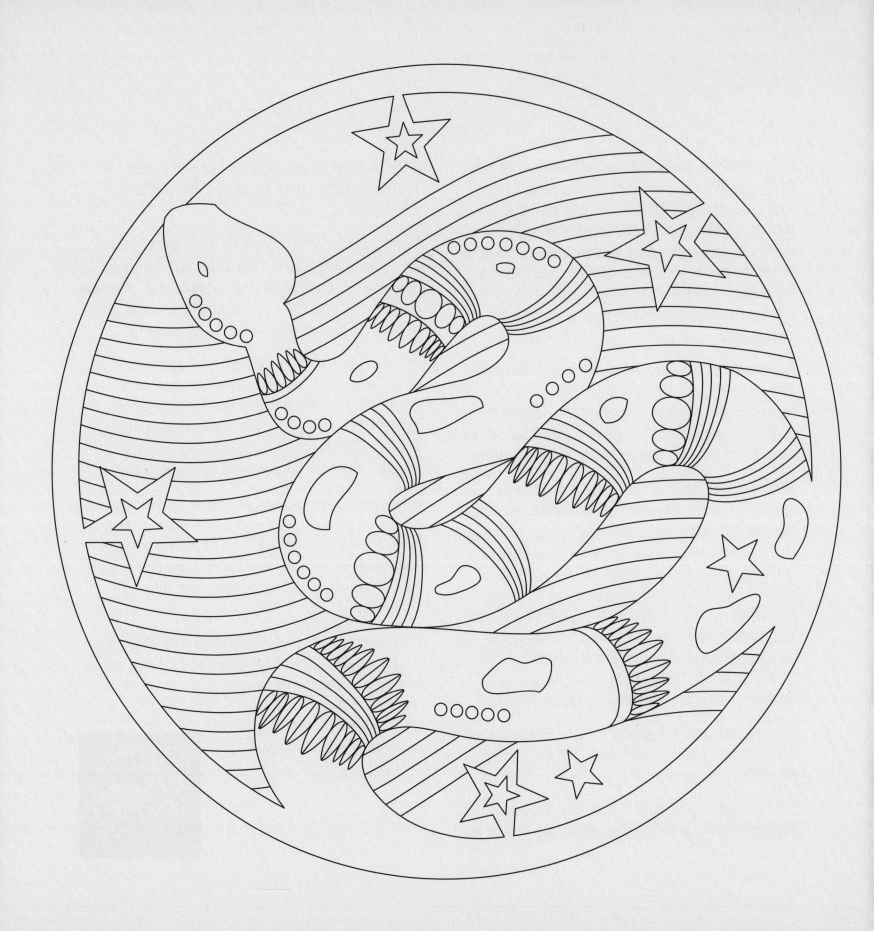

THE MOON AND THE GREAT SNAKE

A Blackfeet Story

Once there was only one Snake on the whole world, and he was a big one, I tell you. He was pretty to look at, and was painted with all the colors we know. This snake was proud of his clothes and had a wicked heart.

The Moon is the Sun's wife. You know that the Sun goes early to bed, and that the Moon most always leaves before he gets to the lodge. Sometimes this is not so, but that is part of another story.

This big Snake used to crawl up a high hill and watch the Moon in the sky. He was in love with her, and she knew it; but she paid no attention to him. She liked his looks, for his clothes were fine, and he was always slick and smooth. This went on for a long time, but she never talked to him at all.

The Snake thought maybe the hill wasn't high enough, so he found a higher one, and watched the Moon pass, from the top. Every night he climbed this high hill and motioned to her. She began to pay more attention to the big Snake, and one morning early, she loafed at her work a little, and spoke to him. He was flattered, and so was she, because he said many nice things to her, but she went on to the Sun's lodge, and left the Snake.

The next morning very early she saw the Snake again, and this time she stopped a long time – so long that the Sun had started out from the lodge before she reached home. He wondered what kept her so long, and became suspicious of the Snake. He made up his mind to watch, and try to catch them together. So every morning the Sun left the lodge a little earlier than before; and one morning, just as he climbed a mountain, he saw the big

Snake talking to the Moon. That made him angry, and you can't blame him, because his wife was spending her time loafing with a Snake.

She ran away; ran to the Sun's lodge and left the Snake on the hill. In no time the Sun had grabbed him. My, the Sun was angry!

The big Snake begged, and promised never to speak to the Moon again, but the Sun had him; and he smashed him into thousands of little pieces, all of different colors from the different parts of his painted body. The little pieces each turned into a little snake, just as you see them now, but they were all too small for the Moon to notice after that. That is how so many Snakes came into the world; and that is why they are all small, nowadays.

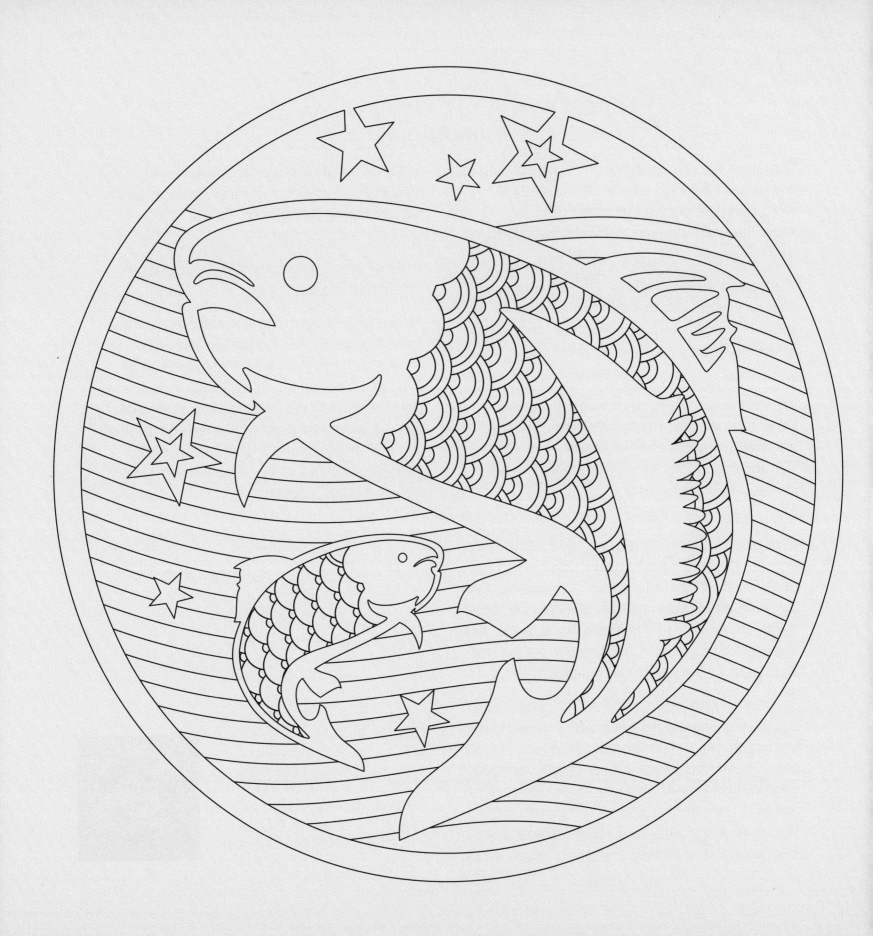

THE SALMON
A Siletz Story

The salmon were actually people with superhuman abilities and eternal lives. The Salmon people lived in great houses under the ocean but since they knew that humans on land needed food, they offered themselves to the land-based tribes as food by turning into salmon fish.

Their spirits were returned back to the ocean where they were reborn. One tribe on land was short of food because the salmon never came to their waters. But they heard about the Salmon people. So the chief sent out an expedition to find these Salmon people in order to ask them to come to their waters.

After many days of travel, the expedition arrived in a new land where the Salmon people were. The chief of the Salmon people ordered four of their villagers to go into the sea where they became salmon as soon as the water reached their faces. He ordered others to retrieve these new salmon fish, which were then cooked as a welcoming feast for the guests in the expedition.

The chief told the guests to eat as much as they wanted, but the bones of the salmon fish, even the smallest ones, were not to be thrown out. All of the salmon bones were collected by the villagers after the guests were careful enough to lay them into little piles. The Salmon people then threw these bones back into the water. Minutes later, the four individuals who originally turned into salmon fish reappeared and joined the others.

Over the next few days, the guests watched the Salmon people repeat this process with the salmon bones over and over again. However, during a subsequent feast, one of the guests from the expedition secretly held back some of the salmon bones. This time, when one of the Salmon people came back from out of the water, he was covering his face and said that some of the bones must be missing since his cheeks were gone. Another said that she was missing her chin. Alarmed by what had happened, the guest brought out the missing salmon bones he had previously held back.

The two Salmon people with missing body parts then went back into the sea with these bones. Upon their return back to land, both people had their complete bodies again.

The expedition asked the chief to let some of his Salmon people visit their waters and streams to help supply much-needed food. The chief agreed to do so as long as the tribe agreed to throw back all the salmon bones into the water so that the Salmon people could return home intact.

He said, "I will send Spring Salmon to you first in the season. After them, I will send the Sockeye, then the Coho, then the Dog-Salmon, and last of all, the Humpback."

So the tribe always honored the return of the salmon to their streams every year and respected the rules set by the Salmon-people chief. This ensured an adequate food supply for the tribe every year.

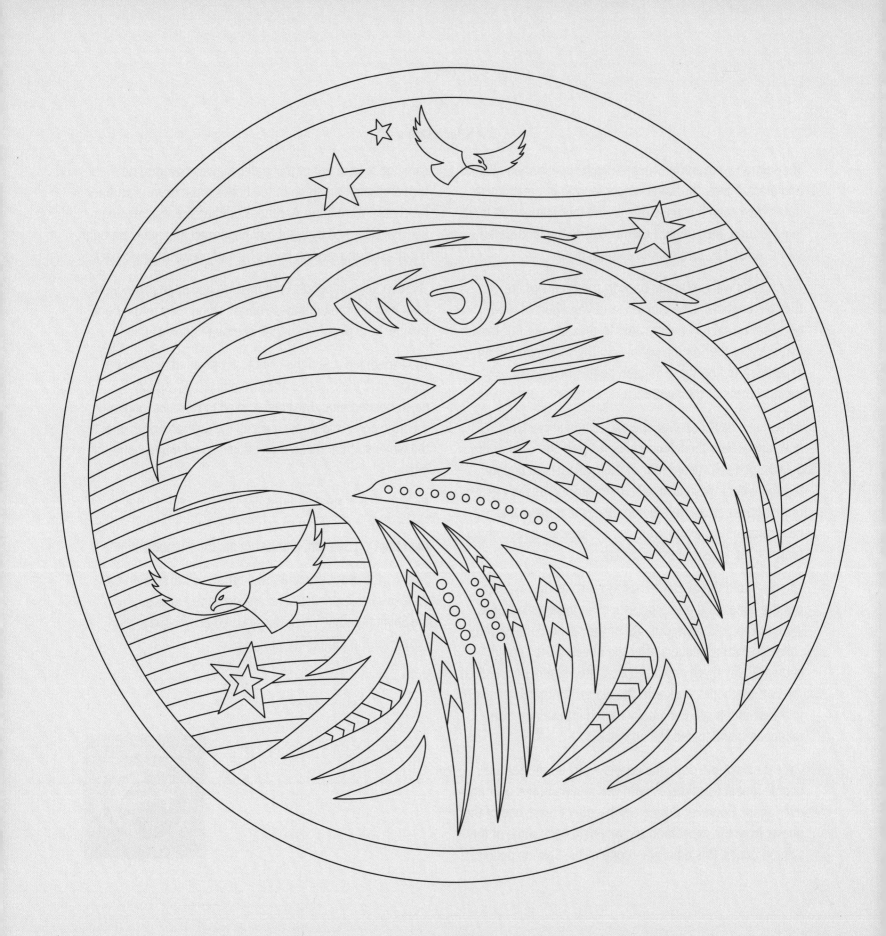

THE GREAT HUNTER

An Oglala Lakota Story

There was once a boy with a great gift. He was to be one of the great hunters in his village. When he was born, his grandfather made him a bow and arrows, a tomahawk, and a knife, and taught him how to use them. When the boy came of age, his grandfather taught him how to use the bow and arrows, to hunt certain animals, and as he got older everyone became aware of his gift.

One day he went out hunting. His parents expected him to return but he did not come home that night. A meeting was called to select the greatest trackers to find his trail and track him down for they feared the enemy might kill or attack him.

The trackers followed his trail. It came to a dead end and there a staff was stuck in the ground. They searched the entire area but found nothing that would tell them more. They returned to the village and reported their findings. The next day, the greatest warriors and horsemen searched out where he might have been killed by the enemy but still found nothing.

The family was worrying about their lost boy. They were sad for they felt he was dead. Someone then walked into the tipi. They all looked up and he had walked in. The news spread around the village. They knew something strange had happened to him and they wanted to know what happened. It was the custom to sit down in ceremony for him to tell his story. And so they held a ceremony for his sharing. And here is his story.

He had gone out hunting for game but there was none to be found. As he was walking at the foot of the mountains, where he could see miles off in the distance, he heard a swishing noise. It was the air swooshing down upon him and just as he looked up, something grabbed hold of him. He saw the greatest claws on the largest eagle he'd ever seen. He grabbed hold of the eagle's legs, but the eagle was so powerful, he had no chance to fight it off. The eagle lifted him and away they flew. The eagle spoke to him saying, "Do not be afraid. I know you are a great hunter and I am in need of your help."

When they landed in the eagle's nest they found two baby eagles nestled in one corner of the nest, afraid of the hunter. They were assured not to be afraid of this hunter who would protect them. The mother eagle then shared her story of why the hunter was brought to the nest.

"I have tried to raise a family here for many springs, but when they reach the age they are now, there is an animal that comes to kills them and eat them. I know you have the power of a great hunter and I brought you here to kill this animal. When it comes this time, you will prepare for him. In the meantime, I will go out to get meat to bring back so you can eat with our family."

For several days the mother and father eagle brought in antelope and other meat which the hunter made into jerky for all of them. Being high up on the bluff, he saw his people trail him but could do nothing.

One day getting toward high noon, as far as you can see,

Continued on next page

eagles soaring making screeching noises, the father eagle swooped down close to the nest and said, "He will come from the edge of the cliff, south from where you are sitting."

The baby eagles fearfully huddled in the nest making screeching noises. The father eagle flew to the nest saying, "He is getting nearer."

The young hunter knelt down inside the nest. With bow and arrows he aimed to where the eagles told him the animal would be. Out of nowhere a huge head, which looked like a bear's head, lifted up so fast that the young hunter could not tell what it was but he instinctively knew right away the animal would lift his head up again. He released his arrow and it hit the animal right between the eyes just as he stuck his head up once more. When the arrow hit, the animal straightened up and fell over the cliff.

The mother eagle made the tremolo sound and the father eagle sang an honor song as they soared the skies. Then they both landed in the nest and the father eagle said, "You have killed the biggest snake which has killed my family for many years. From now on, you will be guided by the eagle people, your power shall be strong and no danger will fall upon you as long as you live. In a few days my children will return you where I found you when I brought you here," and gave him feathers for war bonnets as a gift.

When the time came to leave the nest, the hunter described how he grabbed the legs of the young eagles and stepped off the cliff. At first, their wings came down but the father eagle pulled them up to gain altitude and the young hunter was returned to the place where the eagle had first found him.

STORY INDEX

1 Turtle Gets a Shell *An Anishinabe Story*

Anishnabe *(They are several different tribes. **Anishinabe** is an ethnic term, referring to the shared culture and related languages of the Algonquian tribes of the Great Lakes area.)*

Nanabozho *Nanabozho is the Ojibwe trickster figure and culture hero (these two archetypes are often combined into a single figure in First Nations mythologies).*

2 How the Fawn Got its Spots *A Dakota Story*

Dakota Sioux *The Sioux are a Native American tribe and First Nations band government in North America. The Sioux comprise three major divisions based on Siouan dialect and subculture: the Santee, the Yankton-Yanktonai, and the Lakota.*

Wakan Tanka, The Great Mystery *Wakan Tanka is the term for **the sacred** or **the divine**. This is usually translated as **The Great Spirit**.*

3 How the Bear Lost His Tail *An Anishinabe Story*

Ojibwe *The Ojibwe (also Ojibwa), or Chippewa are the largest group of Native Americans and First Nations Indigenous Peoples in North America. There are Ojibwe communities in both Canada and the United States. In Canada, they are the second-largest population among First Nations, surpassed only by the Cree. In the United States, they have the fourth-largest population among Native American tribes, surpassed only by the Navajo, Cherokee and Lakota.*

4 How Rabbit Brought Fire to the People
A Native American Story

Thunderbirds *The thunderbird is described as a large bird, capable of creating storms and thundering while it flies. Clouds are pulled together by its wingbeats, the sound of thunder made by its wings clapping, sheet lightning the light flashing from its eyes when it blinks, and individual lightning bolts made by the glowing snakes that it carries around with it.*

5 The Legend of the Cedar Tree *A Cherokee Story*

Cherokee *The Cherokee are a Native American tribe indigenous to the Southeastern United States (principally Georgia, Tennessee, North Carolina and South Carolina). They speak Cherokee, an Iroquoian language. In the 19th century, historians and ethnographers recorded their oral tradition that told of the tribe having migrated south in ancient times from the Great Lakes region, where there were other Iroquoian-speaking peoples.*

Ouga Creator

6 Wolf Tricks the Trickster *A Shoshone Story*

Shoshone *The name **Shoshone** comes from Sosoni, a Shoshone word for high-growing grasses. Some neighboring tribes call the Shoshone "Grass House People," based on their traditional homes made from soshoni.*

The Two Wolves *A Cherokee Story*

7 The Loon's Necklace *A Tsimshian Story*

Tsimshian *The Tsimshian is one of the largest groups of First Nations people in Northwest British Columbia, Canada. Their culture is matrilineal with a societal structure based on a clan system, properly referred to as a moiety. Early anthropologists and linguists grouped Gitxsan and Nisga'a as Tsimshian because of linguistic affinities. Under this terminology they were referred to as Coast Tsimshian, even though some communities were not coastal. The three groups identify as separate nations.*

Dentalion white shell *Whiteshells (also known as Cowrie shells or Sacred Miigis Shells) were used by aboriginal peoples around the world, but the words **whiteshell** and **Miigis Shell** specifically refers to shells used by Ojibway peoples in their Midewiwin ceremonies.*

ABOUT THE AUTHOR

Joan Henrik began her graphic design career in Duluth, Minnesota, where she attended the University of Minnesota. She has worked more than 50 years in advertising including over twenty-five years with the Westmoreland, Larson and Hill agency. The National Terrazo and Mosaic Association selected her floor design as one of the best terrazo floors in the United States (2011).